ASTROLOGY
in Medieval Manuscripts

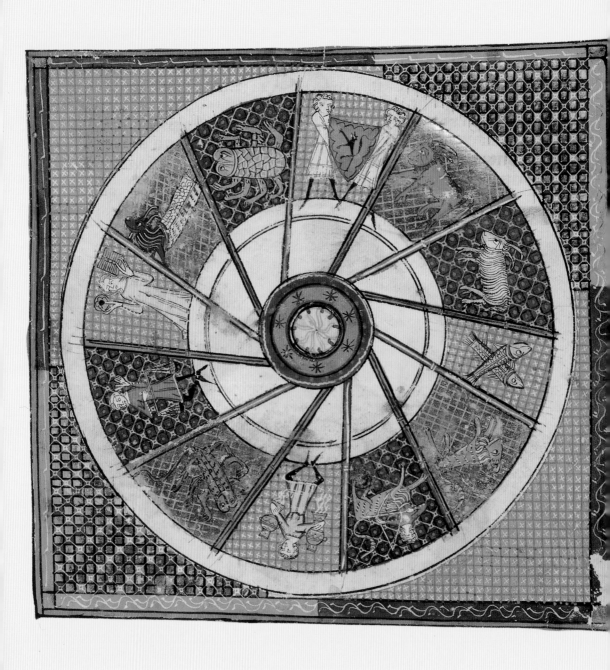

ASTROLOGY
in Medieval Manuscripts

SOPHIE PAGE

THE BRITISH LIBRARY

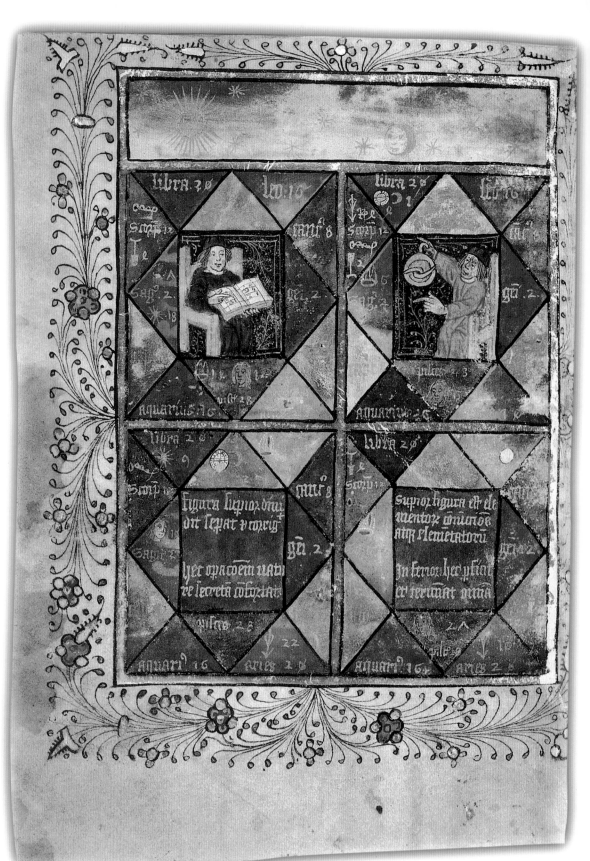

INTRODUCTION

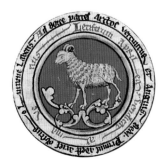

Astrology rests on a perceived symmetry between movements in the heavens and events on earth. As astronomical observation grew in sophistication in Antiquity so too did the art of predicting the consequences of the passages of the celestial bodies through the heavens. An enthusiasm for unravelling the messages of the stars is apparent in many surviving astrological writings from the Middle Ages. The tools and principles of the astrologer's art were gathered into manuscripts which included tables of the positions of the planets and texts on their nature and influences. Traces of its practice are also apparent in surviving horoscopes, maps of the heavens drawn up by astrologers to provide answers to problems ranging from the sublime to the intimate. These reveal a divinatory art far removed in its complexity from the Sun sign predictions in today's tabloid newspapers but similarly concerned with personality types and individual destinies; questions of love and power, health and business. Unlike astrology nowadays the medieval art permeated many layers of society and appeared in varied contexts from cosmological theory and weather-forecasting to alchemy, agriculture and medicine. It was part of the world picture of medieval men and women and was rarely viewed as unworkable in principle, although sometimes astrologers ran the risk of being accused of obtaining their predictions from demons.

Opposite page: Horoscopes from Thomas Norton's Ordinall of Alchymy, late fifteenth century. Add MS 10302, f.67v.

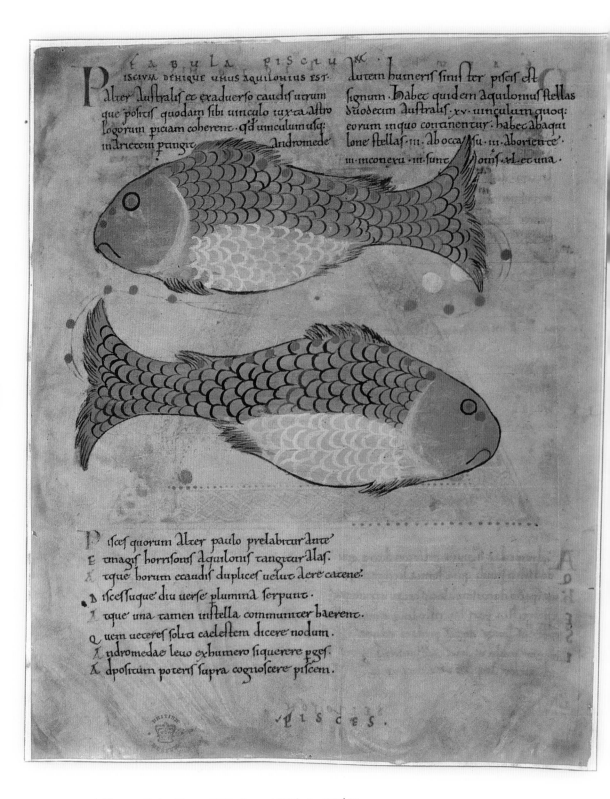

1. *The constellation Pisces, c.1030. Cotton MS Tiberius B V, f.33v.*

THE ART OF ASTROLOGY:
TEXTS AND TRADITIONS

The earliest horoscopes with predictions for an individual's life survive from ancient Babylonia and Egypt, dating to the late fifth century BCE. Refinement of the art occurred in ancient Greece, where the earlier traditions were developed into a scientific branch of learning with a philosophical basis. Following the breakdown of the Roman world and the spread of Christianity in Western Europe the art of astrology, like many other branches of ancient learning, had a mixed fortune. It first reached the Latin West in fragmented form, transmitted in technically unsophisticated textbooks and popular divinatory genres, whose wide diffusion, however, was signalled by regular condemnations by the Church. In the East, Greek astrology was transmitted to the Arabic world where it assimilated Indian, Persian and Islamic sources. This complex art, now an amalgam of many traditions, had breached the borders of the Christian world in Spain by the late tenth century. Flowing in full spate into Europe in the twelfth century, it aroused considerable interest among Christian scholars who saw it as part of a great treasure of ancient knowledge preserved and augmented by their Arab neighbours.

In the early Middle Ages astrological doctrines relating to the nature and influence of the planets and zodiac signs were found in a wide range of texts, particularly works of astronomy, natural philosophy and cosmology. Writers employed the terms astronomy and astrology interchangeably, only using them in the modern sense when speaking of the two complementary aspects – theoretical and practical – of the same science of the stars. Before the twelfth century astronomical skills and interests were mostly found in monastic centres of learning where they were linked to time-keeping and the construction of the Christian calendar. Illustrated astronomical texts (1) were acquired and produced by monasteries because the appropriate times for monastic offices which occurred in darkness could be determined by the identification of constellations in the night sky.

In the absence of accurate astronomical tables and instruments it was difficult to arrive at the precise calculations necessary for horoscopic astrology. Instead, simpler forms of divination flourished, depending for their predictions upon the thirty days of the lunar cycle or the positions of the sun and moon in the zodiac. One

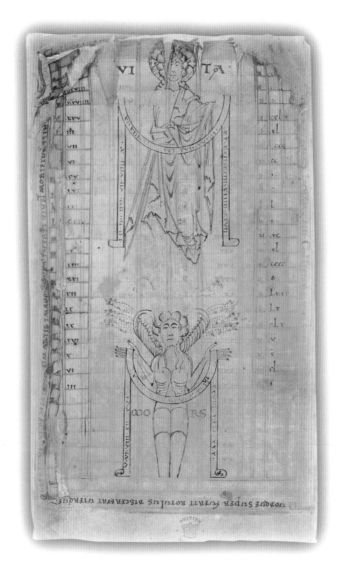

form of divination was called the sphere of life and death, because of its usual circular form (2). It was used by physicians for predicting the course of an illness and probably also by priests deciding whether or not to perform the last rites on an invalid. In this method of divination the total numerical value of the letters of the patient's name (on the principle of 1 for a, 2 for b, etc) was added to the number of the day of the moon on which he or she had fallen sick. This total was then divided by thirty, and if the remainder was found in the part of the table ruled over by the figure of Christ-life the patient would live. Conversely, if it was in the part ruled over by Satan-death he or she would die. Attention was also given to the waxing and waning of the moon in early works of herbal medicine. Instructions in a herbal for

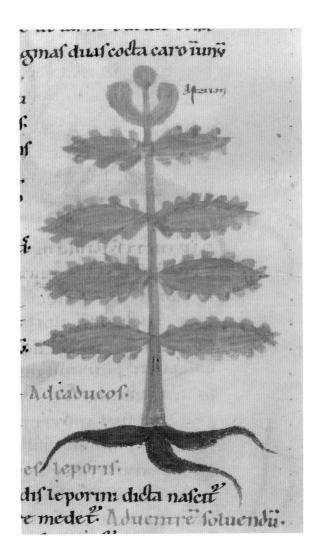

3. The herb Asterion,
tenth century.
Harley MS 4986, f.20.

using *asterion* (3) to cure epilepsy state that the berry should be chewed whilst the moon is decreasing and in the sign of Virgo. This particular plant may have attracted astrological associations because of the belief that at night it shone like a star in the heavens and frightened ignorant people into believing they had seen a ghost.

In the twelfth century astrological studies acquired great impetus with the rediscovery and translation into Latin of Greek texts which had been preserved in the Arabic world and Arabic works of natural philosophy, astronomy and astrology. Scholars from across Europe travelled to centres in Spain, Sicily and the Middle East where – often in collaboration with Jews – they translated works from Arabic into Latin and returned home in possession of a body of scientific knowledge which

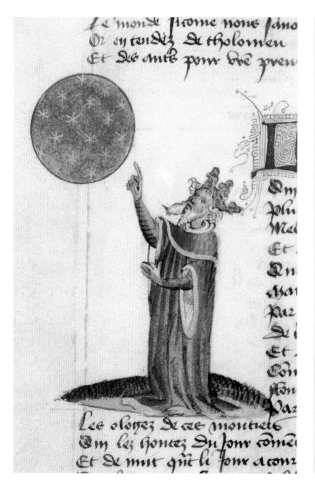

4. The astronomer Ptolemy mistakenly depicted as a king, fifteenth century. Harley MS 334, f.95v.

5. The Arabic astrologer Albumasar, 1443–1444. Add MS 15,697, f.44.

included astrological, alchemical and magical texts. In the climate of optimism surrounding the usefulness of this new learning astrology secured a more acceptable status as an object of study. With the transmission of the *Almagest* (2nd century CE) of the late antique astronomer Ptolemy (4) and Arabic astronomical tables astrologers acquired the ability to produce more accurate horoscopes. Astrological textbooks including Ptolemy's *Quadripartitum* and works by Arabic authors such as Albumasar (5), Alcabitius and al-Kindi provided sophisticated justification for the practice of astrology, clarification of the various astrological genres and systematic rules for the interpretation of celestial configurations. Latin authors were soon motivated to write their own manuals, drawn by the enticing prospect of formulating scientific methods for predicting the future and the financial rewards that these might bring.

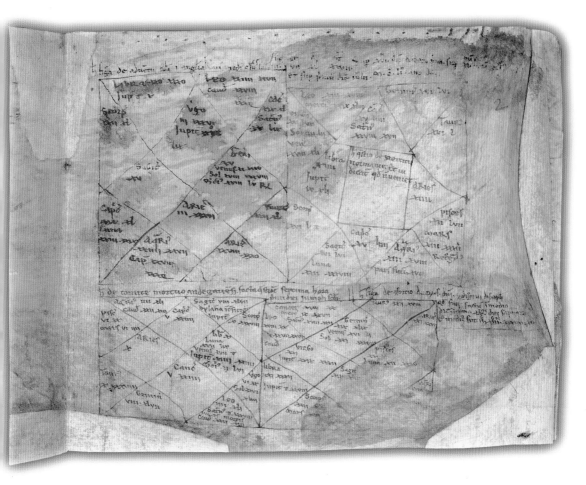

6. Anglo-Norman horoscopes attributed to Adelard of Bath, 1151. Royal App. 85, f.2.

The new astrological learning was disseminated both at the level of the personal horoscope and general prediction. One of the earliest scholars to introduce accurate astronomical tables to the West was Adelard of Bath who has been proposed as the author of ten surviving mid twelfth-century Norman horoscopes, several of which are reproduced here (6). These mainly political horoscopes relating to the movements and actions of various contenders in the Civil War following King Henry I's death – King Stephen, Matilda's second husband Geoffrey Plantagenant, and her son, the future King Henry II of England – indicate the complementary association of astrology and Court culture. Adelard of Bath taught the youthful Henry when he resided at Bristol in the 1140s and dedicated a treatise on the astrolabe, an instrument used for astronomical and astrological purposes, to him.

But the concern expressed in the top right-hand horoscope over the arrival of a Norman army suggests that the astrologer or patron linked to these particular horoscopes was a supporter of King Stephen, whose fears were realised when Henry invaded England in 1153.

Arabic astrological textbooks translated into Latin introduced new genres of astrology as well as more sophisticated techniques to the West. Evidence for the growing influence of astrology is provided by reactions to a conjunction of all the planets in the sign of Libra in September 1186. A conjunction is one of the five major planetary aspects – configurations in the heavens which were of particular significance to the astrologer. Conjunctionist astrology was developed in the works of Arabic astrologers, who interpreted the appearance of planets on the same degrees of longitude as the signs and causes of great historical events, notably those linked to religion, prophecy and political upheaval. The conjunctions of Jupiter, Saturn and Mars were thought to be particularly significant but widespread interest in the conjunction in Libra in 1186 was aroused by the large number of planets involved. Various predictions relating to this conjunction were recorded by Roger of Hoveden, an English chronicler (7). Among these, the astrologer Corumphiza predicted the rise of a violent and extremely powerful storm 'blackening the air, and polluting with the stink of poisonous vapours. From this cause, many people will be seized by death and sickness, and loud noises and voices will be heard in the air, terrifying the souls of those who are listening'. Another astrologer, the Arab Pharamella, derided the poor skills of Christian astrologers, and provided an alternative but equally negative prediction. He stated that 'if God does not provide otherwise, there will be a poor vintage-grape harvest, a moderately sufficient harvest, many massacres by the sword and a greater number of shipwrecks.' Although widespread panic was reported in England as the day of the conjunction approached, the chronicles record that nothing more violent than a hailstorm in Kent and floods in Wales transpired.

Opposite page:
7. Predictions relating to the 1186
conjunction of planets in Libra,
fifteenth century.
Cotton MS Claudius E VIII, f.3.

onibus hiis ⁊ aliis conuencionibus quietu clama
uit ipm regem Ric̄. ⁊ heres suos q̄ lr̄ sc̄e ffid.
L.vi. anū regn̄ Ric̄ in̄. Preterea pdc̄s impe
rator cedit reḡ Anglie ⁊ carta sua confirma
uit has lr̄as subscriptas. s. Pruinā ⁊ Vianam
⁊ Vialens. ⁊ marchiā ⁊ Aertonā. ⁊ Arle le blac
leouiu sup Rodanū usq̄ ad Alpes ⁊ quicq̄d
pat̄ habet in Borgundia ⁊ homagiū regis
Aroganie ⁊ homagiū comitis de vissers ⁊
homagiū comit̄. s. Egidii. Et est sciend q̄d
in hiis tr̄ibus sūt. v. Archiepāt. ⁊ xxxiii. ep̄at
Et est sciend q̄d sup ōes impator nꝰ ūqm pōs
tris ⁊ vonus. Dūiari potuit neꝰ ipi ali̓ dr̄m
ad sentacōnem impatoris reꝙ̄ uoluerūt
q̄ ut sup regn̄ Regis Ric̄ in̄.

Clemens ep̄s seruus seruoꝝ ci̓ r̄. Cum
iu venirit ⁊ iugo sc̄ietati ⁊ i. Ca. ꝙ Riue in
xp̄o fili reuerantiam ac deuocōne q̄ ad Rom̄an
te tuisse alonge rex templq̄. etiam nouitu̓
attendens p̄sentis sc̄ipt pagina duximus sta
tuendū. Vt sco̓arana etiam aplīce sedi ac alia
speciali exstat nulla mediante debeat sbiacere.
in qua hec sedes epales ee noscant. Smilē
niee tū Andree Glasnētis. ꝩ kelētis.
Brehinēs. Abdouēs. Morauyēs. Rosouēs.
Catinēs. Et nemini liceat n̄ rōno pontifi
cū ur̄ legato ipi lateri destinato regni scotie
in̄di ur̄ ex cōis sentenā. pmulgat̓ si pro
mulgata sūt dr̄cuiꝰ n̄ valeꝛ. q̄ in ē ut sup
au st̄. M. C. lxxvm. i̓ fi.

Anno grē. M. C. lxxxiiii. Astrologi ore̓
tales ⁊ occidentales. iuxta s. ⁊ saracē
mi xp̄iani miserūt lr̄a p diu̓sas mūdi p
tes p̄ouentes ⁊ absq̄ dubio asserentes ⁊ septēb
tursm̄ validoꝝ uento̓ tempestate ac ter̄
motu ⁊ mortaliter hoīm sediciōes ⁊ alia mul
ta cōminantes i̓ hunc unicuum s. ali̓ fore
q̄ dūinando p̄ dixerat manifeste euenit tū
legins cerū tū q̄ ex hiis lit̄a audisit primus
turbat̓ est ualde ⁊ quanto mag̓ illud temp̄
pestifer qꝰ p̄dixerat p̄tim Astrologi appro
pinqꝫ tanto mag̓ omnes parit̓ clericos ⁊
laicos ⁊ diuites ⁊ pauperes maxim̓ amor
tu̓ uastit̓. ⁊ q̄ plures illoꝝ in disp̄acōnem
sūt. Erat tam̄ eis solaciu̓ scituū q̄d nū
Jaramella filiꝰ Abdalabi Cordubensis mi
sit Ioh̄i Sholetano ep̄o i̓ hc̄ fo̓.

Jaramella filiꝰ Abdalabi Cordubēs
ex grāie Arabū mutū ⁊ erudit̄ in pala
cio magn̄i regis Euenaroꝛ ⁊ q̄ nominat̓ Velitri
ra nimod̄ Ioh̄ Tolano cor̄ qui tam dicitur
ep̄o salt sup ōnes qui in nocrkt dm̄. Qui ti
ment dm̄ creatorem suū exaltabūt ⁊ nꝰ ad
orant cum puris manib̓ ⁊ toto corde Abdu
to iudiciꝰ quoscā boīes scete ur̄. habitu nob
king dissiles. qui negociatores erant ⁊ pan
nos laneos diuersoꝝ coloꝝ satis bonos uena
les habebant. Dicebat̓ se venisse de terra
longinq̄ꝰ. q̄ dr̄ t̄ra maioꝛ ⁊ regū fricommu
urt ē. didimus habēs p̄incipe ferandū no
mine ꝙ̄tue urn̄ hodie captiuū dr̄m ex
quinē falsi astrologi et occidente nesciuntis u̓
tutem celestiū corpꝝ ⁊ esfentiū. v. uagan
tiū. duoꝛꝫ q̄ luminiū iuenal ⁊ scretis cir
cul suis p domos ⁊ dignitates suas sese mo
uentium trunerūt corda crediuū in ep̄m
uriū non tm̄ eoꝝ qui simplices sūt. s̄ꝫ
eoꝝ q̄ apud uos sapientes ee crediūt. dicunt
n. q̄ ōno qui est ānus allige quingentesim̄
iiii. q̄ est āni. M. C. lxxvi. ab incarnacōe
dm̄. mense q̄m dicūt septēbris turtus est
uent̓ maxim̓ ꝯr̄e est nō solu̓ edificia subu̓
tens ciuitates ⁊ apica diruentes. q̄ꝫ sup
ram occurrit euntes. Veniet ⁊ uentus ut
dicūt ab Occidēte ⁊ p̄tiger usq̄ in Open
tem. ⁊ p̄ uentū fetoꝛ pessim̓ homines i̓
terfaciens. Cuꝰ rei nulla caū reddit̓ misi
q̄ planete conueniet in libra q̄ est siḡ
na aeriuū ⁊ ideo uentosum. Munᵭꝛ stati
aplīs nr̄is respondere potest. q̄ nō solum
nō sup aeriū est. s̄ ⁊ Gemini ⁊ Aq̄rius siḡ
sūt aeria in q̄ utroq̄ plures planetaꝝ
non nūqm conuenerūt. n̄ tū aut uentoꝛ
aut feroꝝ. aut mortalitatis p̄ialum
secut̓ est. s̄ ⁊ in Saturn̓ ⁊ mars duo sūt
infortunata. Jupiꝛ aut ⁊ venꝰ fortuna
te sūt stelle. ⁊ q̄ie. si i̓ eodem signo fue
rint aꝝ sine respectu. aut applicatōne.
aut pp̄ortionale se iuent. benignitas eoꝝ
maliciā supioꝛ temp̄ad. Venꝰ a die
q̄d tursū dicunt. mars non in liū. sed
⁊ i̓. virginis venꝰ autem i̓ scorpione
q̄ est comus martis. totam ipi̓ malitis
maliciā extinguet tū xp̄ eius comū iuxa

THE ART OF ASTROLOGY:
TOOLS AND PRINCIPLES

The aspiring student of astrology in the late Middle Ages had to master both the astronomical and mathematical techniques necessary for constructing a horoscope, and a complicated series of rules for interpreting the celestial configurations represented in this essential diagram. After the twelfth century, the requisite astronomical skills would usually have been acquired by students studying the *quadrivium*, the mathematical subjects of the Arts degree at University. Astrological skills were also considered essential for medical students. Occasionally astrology itself was a prominent part of the curriculum – Bologna University had its own professor of Astrology who taught a four-year course in the fifteenth century. Astrological teaching was relatively uniform, although students of the art could choose from various competing techniques and systems circulating in manuscript form. Because of the predominantly practical value of texts concerned with the tools and principles of astrology, these were not usually richly decorated, although diagrams frequently formed part of the explanatory apparatus.

The main tool of the astrologer was the horoscope or astrological chart, a symbolic map of the heavens at a particular moment and place. In this figure the astrologer plotted the positions of the seven known planets (the moon, Mercury, Venus, the sun, Mars, Jupiter, Saturn) as they appeared in the zodiac, that is the zone centred upon the ecliptic, the apparent path of the sun around the earth. The zodiac was divided into twelve equal parts of thirty degrees named after the constellations once present in them: Aries, Taurus, Gemini, Cancer, Leo, Virgo, Libra, Scorpio, Sagittarius, Capricorn, Aquarius and Pisces. Situating the horoscope in relation to a particular location on earth was achieved by superimposing the division of the ecliptic onto the horoscope where it intersected with the horizon and the meridian at the appointed time. This was usually called the division of houses and gave the horoscope its characteristic framework of twelve places (or houses). The most common method of calculating this division started with the degree where the ecliptic intersected with the horizon, called the 'ascendant'. The astrologer then constructed the divisions of the six houses beneath the horizon in the order of the

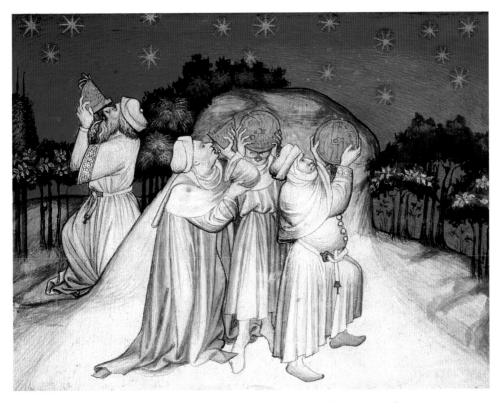

8. *Astronomers on Mount Athos inspecting the heavens, fifteenth century. Add MS 24,189, f.15.*

rising of the signs; and the six houses moving from east to west above the horizon towards their setting point.

The position and distance of the planets was calculated with the aid of instruments such as astrolabes and quadrants which were trained on the sun during the day and on a prominent star at night to give readings for the current time (8). Astronomical tables adapted to different latitudes facilitated the calculation of the twelvefold division of the local sky and the computation of 'ephemerides' listing the daily positions of the planets. One example of these (9) shows the first folio of a series of tables with the motions of all the planets for 1400–1500. The ephemeris for July 1450 (10) from the notebook of a fifteenth-century London astrologer, Richard Trewythian, was probably calculated from such a table. This has columns for each of the planets and the points where the moon crossed the ecliptic (called *caput* and *cauda draconis*). Below the symbols of these are the names of the zodiac signs in which each planet is placed. The rows of the table contain not only the daily positions of all the planets to the degree and minute but also, at the far right, symbols representing the

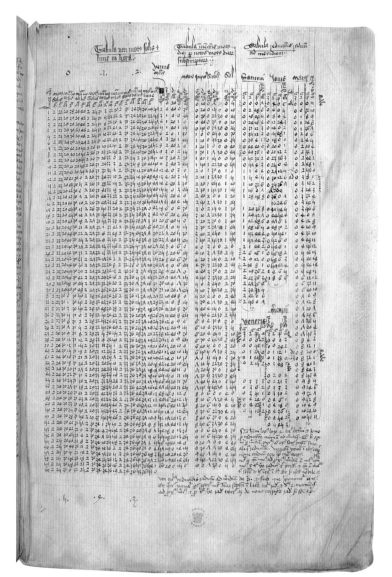

Left:
9. *Astronomical tables,*
fifteenth century.
Royal MS 12 G X, f.3.

Opposite page:
10. Richard
Trewythian's
ephemeris for July
1450 with a
horoscope of an
eclipse. Sloane MS
428, f.55.

significant planetary configurations or aspects, occurring on a given day. At the bottom of the table Trewythian has drawn up a horoscope for an eclipse which occurred on 24 July, 1450. Above it is a judgement predicting war on 1 July, 'because of the square aspect between the two heavy planets (Jupiter and Saturn)'. In the left-hand margin he notes a terrestrial event on the 4 July corresponding to this prediction: 'on this night the people of Kent made war on London bridge', a reference to an event in Jack Cade's rebellion.

Horoscopes appeared in a variety of square and circular forms in the Middle Ages, of which Trewythian's is a fairly common kind. The twelve 'houses' are counted

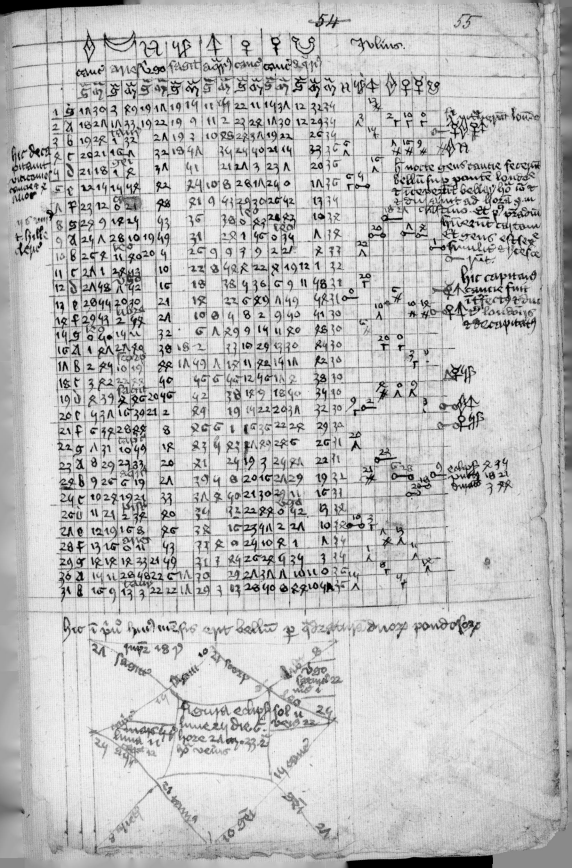

11. *The Sun: a planet masculine, diurnal, warm and dry, c.1350.*
Add 23770, f.34.

in counterclockwise direction from the triangle left of the centre and the boundary of each house in terms of the degree of the zodiac sign is indicated as well as the positions of all the planets and *caput* and *cauda draconis*. The central square of the figure was often used for information relevant to the purpose of the horoscope such as the date, the name of the client or the question needing to be answered. Once the horoscope had been constructed, the astrologer worked his way through various levels of signification to produce a judgement. Each planet in the horoscope possessed natural properties, being male or female, diurnal or nocturnal, hot, cold, dry, or moist, benefic or malefic, etc (11 and 12). Other significations depended on their position in the horoscope and their relationships with other planets. The zodiac signs were also classified in various ways: according to the sexes, seasons and elements (the four 'triplicities' of fire, earth, air and water), and 'cardinal', 'fixed' and 'mutable' signs. All the planets ruled over two signs called their 'houses' except for the Sun and Moon (considered planets in the Middle Ages) which ruled only one. When a planet was present in a sign it ruled its influence was more powerful, but in the signs diametrically opposite to these in the horoscope it was in its 'detriment',

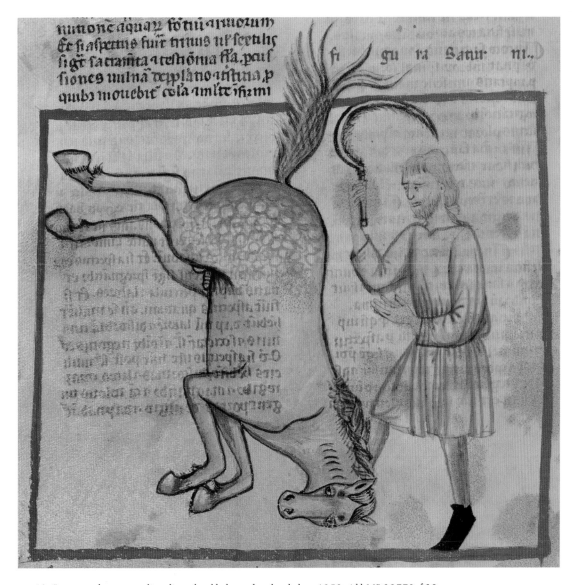

12. *Saturn: a planet masculine, diurnal, cold, dry and melancholy, c.1350. Add MS 23770, f.29v.*

and of weakened influence. Planets were also considered strong in the sign of their 'exaltation' and weak in their 'fall', the sign opposite their exaltation. A vivid tinted drawing of Venus (13), made in the second quarter of the fourteenth century, depicts her status in her ruling signs of Virgo (corrected in a later hand to Libra by giving her a pair of scales to hold) and Taurus, and signs of detriment, Aries and Scorpio.

Each sign in the horoscope was further subdivided into various parts, the most important of which were the faces (of ten degrees each) and terms (of varying lengths) which, like the signs themselves, were ruled over by particular planets (14).

Following pages: 13. *Venus with her ruling signs and in detriment, fourteenth century. Sloane MS 3983, f.42v-3.* 19

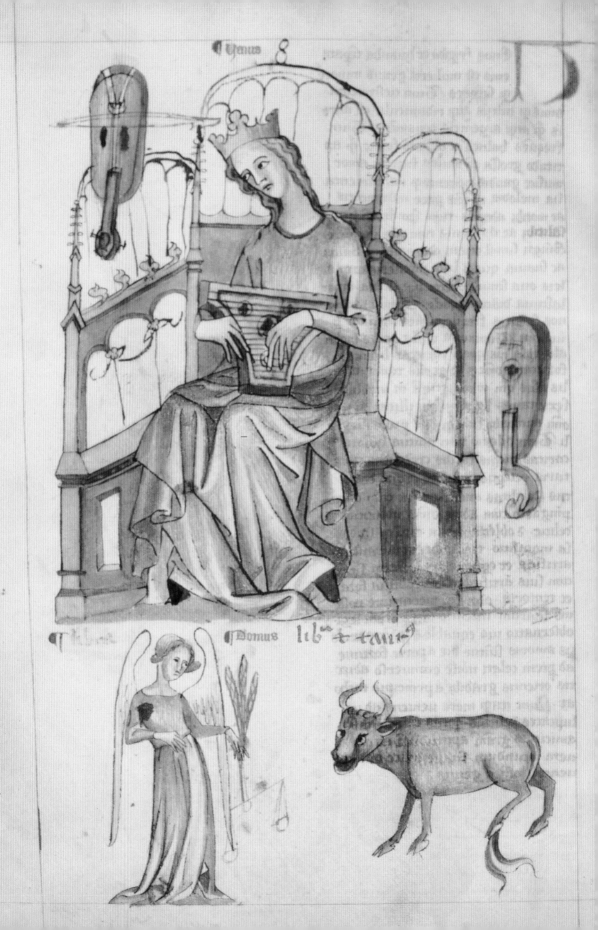

Venus

Exaltatio

Domus lib̄a ⁊ taurꝰ

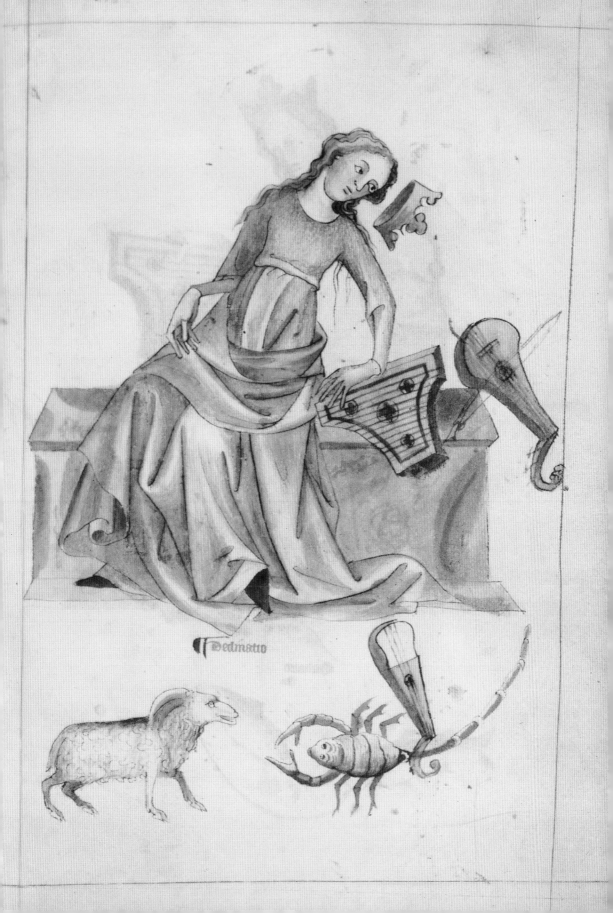

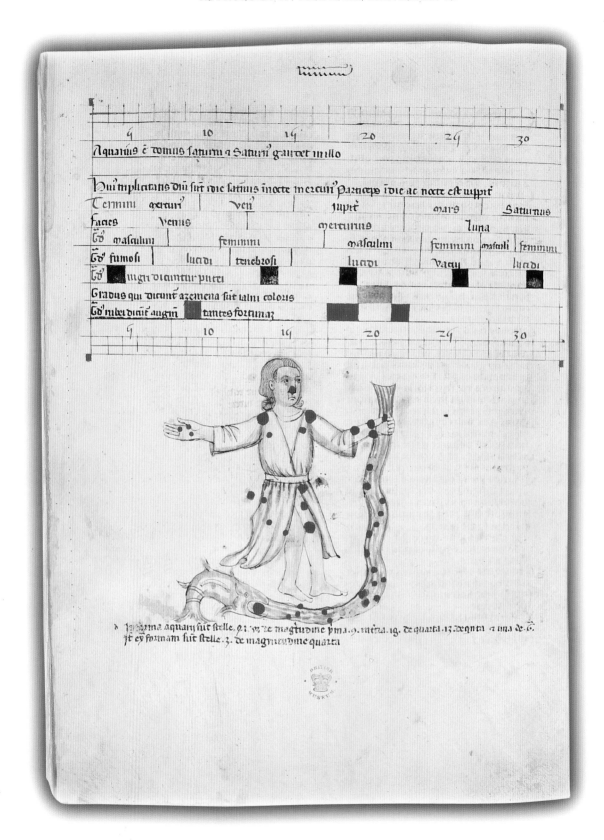

14. The classification of Aquarius, c.1350. Add 23770, f.20v.

The strength of a planet's influence in the horoscope depended upon the 'dignities' it acquired by being placed in its own house, exaltation, triplicity, face or term. The number of points each dignity bestowed is given at the top of a useful diagram (15) which presents a table for locating the total number of dignities a planet acquired in every sign. In the upper part of the diagram the properties of each sign are revealed. Pisces, for example, belongs to the group of signs (triplicity) classified as water, cold, humid, phlegmatic, north and feminine. This classification could affect the astrologer's interpretation in various ways. While the conjunction of planets in the airy sign of Libra in 1186, aroused fears of terrible winds, that in the watery sign of Pisces in 1524 caused many predictions of flooding.

The twelve places or houses were important elements of the astrologer's interpretation because they were associated with different aspects of an individual's life. In the Liber astronomicus of the thirteenth-century astrologer, Guido Bonatti, whom Dante placed in Hell, a typical description of the subjects of the houses is given: I the form and figure of the person (called 'the native' in astrological texts) and the qualities of his soul, II possessions, III brothers, IV parents, V children, VI illnesses, VII marriage, VIII death, IX journeys and religious faith, X authority, XI friends and XII enemies. The first, fourth, seventh and tenth houses were called the cardines or angular houses, the second, fifth, eighth and eleventh, the succedents and the third, sixth, ninth and twelfth, the cadent houses. Planets placed in houses belonging to the first group were said to have a heightened influence, those found in the last, a diminished influence. Different aspects of the native's life were also governed by the 'lots' or 'parts', a series of degrees calculated by adding the degrees between two planets or significant points in the horoscope to a third (often the ascendant), the most significant of which was the lot of fortune.

Finally, and most importantly, the astrological judgement depended upon the planets' positions in respect to each other. The most important of these were the angular relationships between planets called 'aspects', illustrated here with their symbols in a circular horoscope (16). A conjunction occurred when planets appeared to occupy the same space in the sky (0°), at opposition they were 180° apart, square 90°, sextile 60° and trine 120° apart. Each aspect had a particular negative or positive meaning within the horoscope, and conjunctions and oppositions between planets were sometimes considered so important that horoscopes were drawn up especially

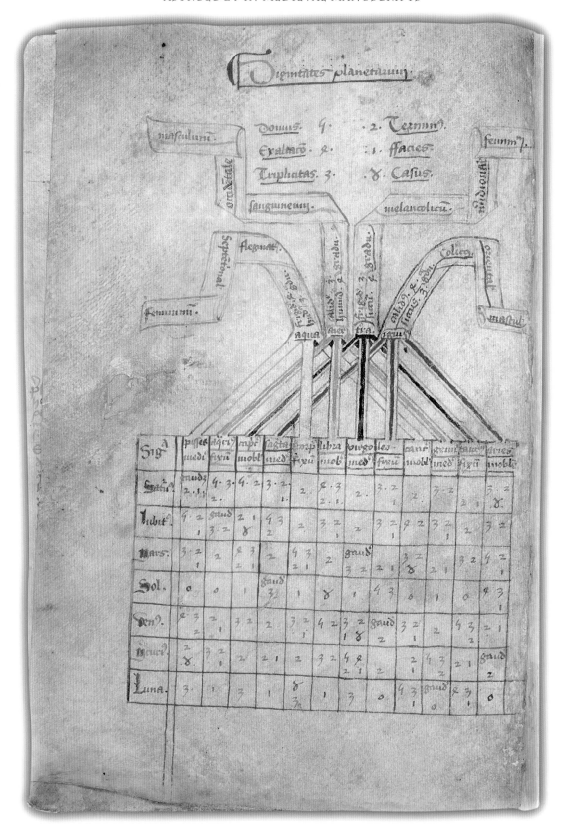

15. *A diagram showing the dignities of the planets, fifteenth century. Sloane MS 332, f.9v.*

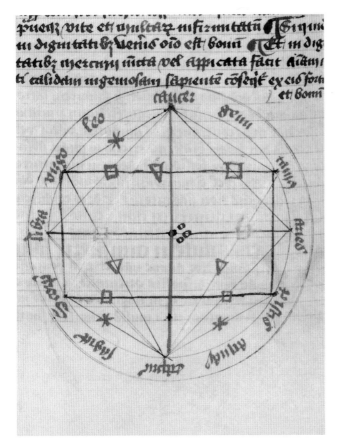

16. The main planetary aspects, 1490. Arundel MS 66, f.158v.

17. Venus under the rays of the Sun, 1490.
Arundel MS 66, f.203.

to interpret their signification. The strength of an aspect depended upon the nature and position of the two planets involved and whether the swifter moving planet was approaching the planet with which it was forming an aspect (application) or moving away from it (separation). Relationships between the Sun and other planets were particularly important. If a planet was within 17 minutes of the Sun (there were 60 minutes to each degree in the horoscope) it was 'cazimi' or 'of the heart'. Within 8½ degrees it was 'combust', and within 17 degrees, 'under the rays'. All these had differing significance for the astrologer, as a depiction of Venus under the rays of the Sun reveals (17). According to the accompanying text, when the Sun was ruler of the ascendant (Leo) and therefore in a position where it dominated Venus, ruler of the Midheaven (Taurus, the tenth house of authority or Kingship), the Sun would represent the King in the horoscope.

THE PRACTICE OF ASTROLOGY

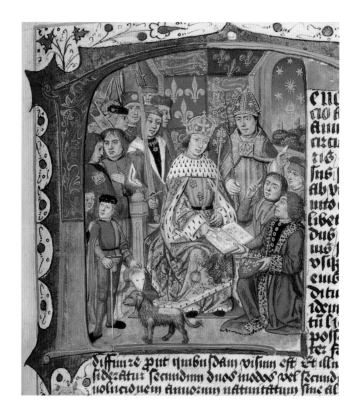 The art of astrology was divided into two main branches: mundane astrology (also called natural and general) and judicial astrology. Mundane astrology was concerned with celestial influences on natural phenomena such as the weather and the prediction of general events. Included in this category were annual revolutions (horoscopes of the sun's entry into Aries, the beginning of the astrological year) and horoscopes calculated for such celestial phenomena as conjunctions, oppositions and eclipses. A miniature in a copy of Bonatti's *Liber astronomicus* depicts this work being presented to King Henry VII (18). It is appropriately placed in the section dealing with annual revolutions in order to link the King as a significant mover on the world stage with events of widespread impact on his realm: the fertility of the land, warfare and plague, and all levels of society. The prominence of the King, a soldier and an Archbishop in this illustration is echoed by Bonatti's instructions to the astrologer to find the planets signifying the King, soldiers and bishops in the horoscope. The presenter of the book and the

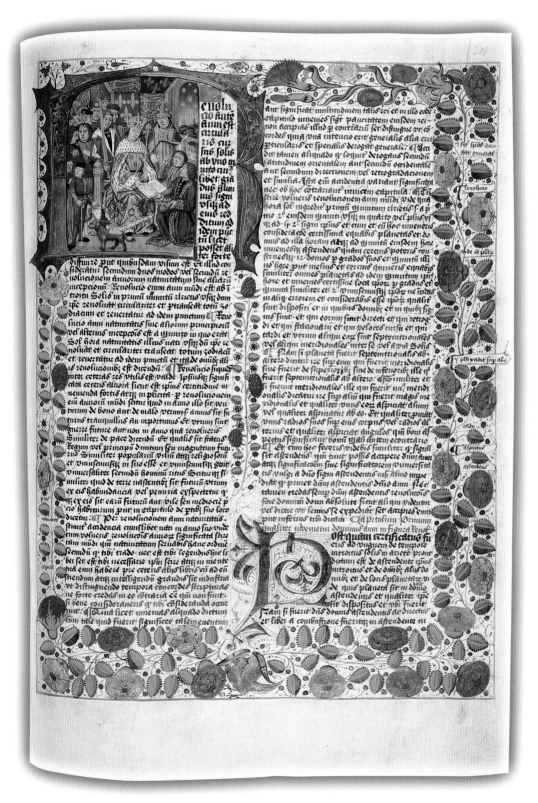

18. The presentation of an astrological textbook to King Henry VII, 1490. Arundel MS 66, f.201.
(See detail opposite page.)

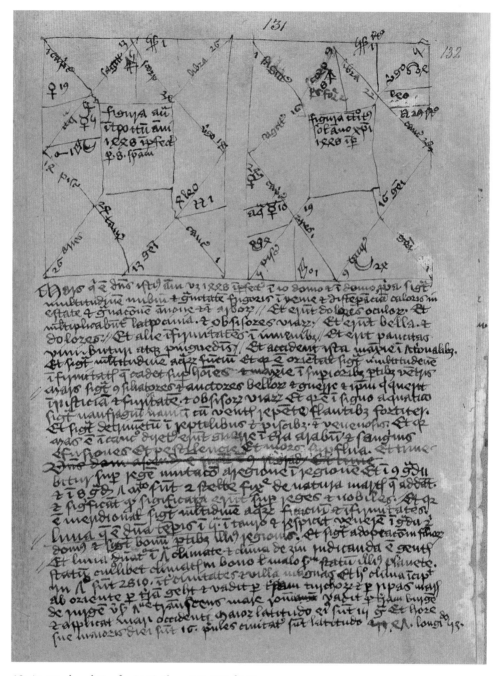

19. *An annual revolution for 1448. Sloane MS 428, f.132.*

archbishop at his side point to a distant view of the sun, moon and other planets, giving astrology the seal of religious orthodoxy and impressing upon the King the momentous possibility of reading the future in the stars. In many courts of medieval Europe rulers received astrological advice from physicians and clerks. Although the

practice of consulting astrologers was regularly condemned by courtiers and theologians, its frequent occurrence is shown by contemporary documents and surviving astrological manuscripts like this one, which were exquisitely decorated for their royal owners.

Astrological knowledge permeated all social levels and the annual revolution for 1448 (19) was constructed by the astrologer Richard Trewythian, mentioned above. Also a physician and money-lender, he had astrological clients ranging from artisans to an Abbot. This prognostication begins by naming Mars the Lord of the year, as the planet with the most dignities in the (right-hand) horoscope. A list of general predictions caused by the influence of Mars in Scorpio in the tenth house is followed by the significations of other important planets in the horoscope. Mars signifies a range of doleful events beginning with: 'a multitude of clouds and severe cold in winter and an excess of heat in summer and disputes over produce and trees. And there will be sicknesses of the eyes and robberies and highwaymen will multiply on the streets.' Astrologers would have had several texts to hand containing lists of significations for all possible combinations of planet, zodiac sign and house. Trewythian consulted Ptolemy's *Quadripartitum* alongside 'Ali Ibn al-Ridwan's commentary, 'Ali Ibn Ali Rijal's *De iudiciis astrorum* and works by Albumasar and Messahala. He was probably also influenced by his own experience of astrological forecasting and by contemporary events and anxieties. Trewythian's prediction of effusions of blood, war, pestilence, death and fear in 1448 would not have aroused much surprise. In the turbulent mid fifteenth century, conflicts between factions trying to control the vacancy of power presented by Henry VI's weak kingship began to take the form of the armed confrontations known as the 'Wars of the Roses'. Dramatic celestial phenomena were believed to have a significant influence upon the earth, and for this reason Trewythian also constructed a horoscope for an eclipse (19, left-hand side) occurring before the entrance of the sun into Aries, in order to assess its influence upon the year. In medieval chronicles, eclipses and comets (20) were often said to presage the death of the King, war, plague or some other disaster.

20. *Man observing comet, c.1350. Royal MS E VI, f.340v.*

Judicial astrology focused on the individual and provided more specific predictions for an individual's life and the correct time for performing an action. It therefore came under suspicion from medieval Churchmen who saw it as presenting a threat to the concept of free will and the Divine providence of God. A common

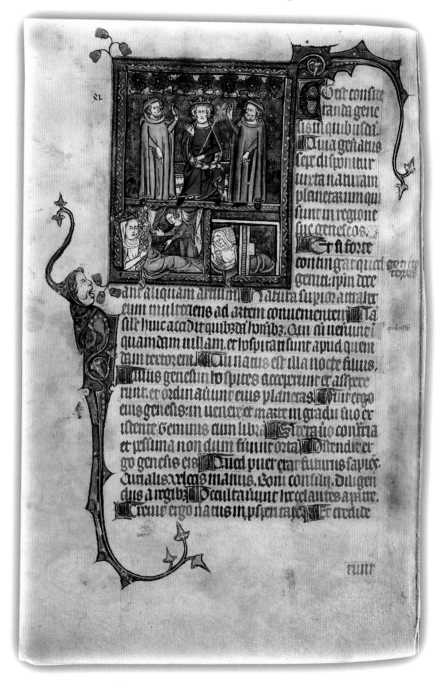

21. *A king consulting astrologers after the queen has given birth, c.1327. Add MS 47680, f.31v.*

response from astrologers to this criticism was that the wise man ruled the stars and foreknowledge of events eased their impact and enabled men to prepare for disaster. Judicial astrology includes the genre of astrology most popular today: natal astrology, and others of almost equal interest to the medieval astrologer: horary (or interrogational) and electional astrology.

A nativity horoscope is a representation of the heavens at an individual's time of birth. It provided information concerning the native's character, the course of his or her life and the time and manner of his or her death. Since accurate records of the time of birth were not always kept except in aristocratic or wealthy households the astrologer sometimes had to reconstruct the time of birth by looking at significant 'accidents' in the native's life. A popular book of political and moral advice for princes, the *Secretum secretorum*, advised rulers to consult astrologers in order to be aware of the natural inclinations of their children (21). Bonatti's *Liber astronomicus* illustrates the celestial influences on a new-born child in the form of a star directing its rays upon the infant's head (22). In this text the native's character and life are dealt with by examining each of the astrological houses in turn from the form and figure of the native's body (first house) to the hidden enemies they would encounter (twelfth house). In each area of the native's life a different planet is prominent. Regarding marriage this is the planet Venus, while Bonatti states that 'for an

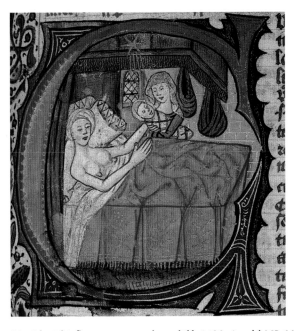

22. *Celestial influences on a new born child, 1490. Arundel MS 66, f.148.*

investigation of the faith of the native and the profundity of his knowledge you must look at Mercury'. Different aspects of each topic are also treated. When considering the native's siblings, the astrologer is able to predict their sex and number, which will die first, and which will live longest. Bonatti also introduces the opinions of other astrologers, giving, for example, Ptolemy's opinon on which of the siblings indicated by a horoscope will achieve prosperity.

Hiring an astrologer to construct a horoscope for the King's nativity was a dangerous undertaking because these charts were believed to reveal the time and manner of the native's death. Different versions of King Henry VI's nativity survive – both those which were officially sanctioned and others associated with more treacherous intentions. A nativity was drawn up at the time of his birth (23) by the mathematician and astronomer John Holbrooke who seems to have offered astrological advice to both this King and his father, Henry V. During the former's reign, however, two clerks were accused of conspiring to use astrology and magic to secure the King's death in collaboration with the ambitious Duchess of Gloucester.

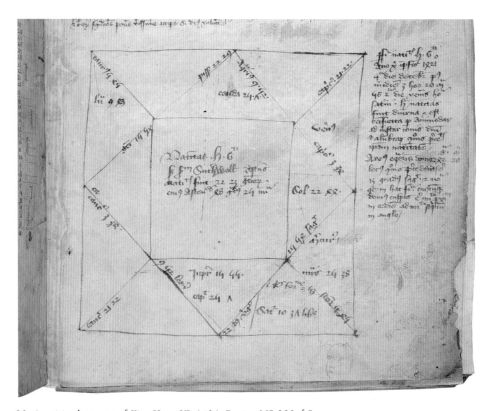

23. *A nativity horoscope of King Henry VI, 1421. Egerton MS 889, f.5.*

Even though their horoscope seems only to have revealed the likelihood of the King suffering an illness, Thomas Southwell died in gaol and Roger Bolingbroke was executed while the Duchess herself was condemned to life imprisonment. Practising astrology was not itself the crime, since an astrologer friendly to the King's party was immediately commissioned to overturn the previous unfortunate predictions and offer a more reassuring interpretation of the King's nativity. Astrology was most vulnerable to attack when it was linked to the practice of magic: the two clerks and the Duchess were accused of practising necromancy (magic involving the summoning of spirits or demons) as well as astrology to bring about the King's death.

Nativity charts had the potential to be of continuing usefulness through the practice of constructing horoscopes on the native's birthday. The positions of the planets in these 'solar returns' were compared to those in the nativity chart in order to make predictions for the year ahead. Richard Trewythian regularly practised this astrological genre, and in one example from his notebook (24) even drew a little face in the central square of the horoscope which is undoubtedly a self-portrait. Although no

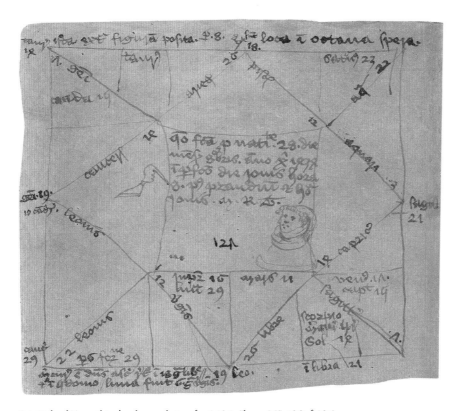

24. Richard Trewythian's solar revolution for 1434. Sloane MS 428, f.126v.

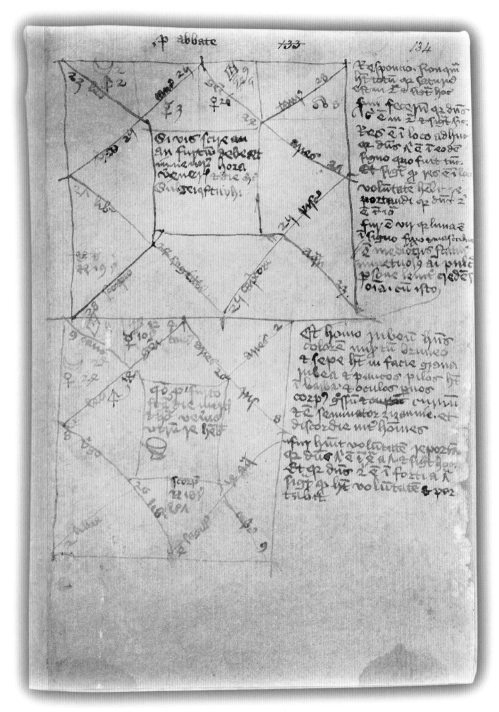

25. *Horary charts for an Abbot, c.1455. Sloane MS 428, f.134.*

predictions survive for this 1434 revolution of his nativity, a judgement does accompany the horoscope constructed on his fifty-second birthday: 28 October, 1445. Here Trewythian notes that 'Jupiter and the Sun in this revolution signify an

improvement of the body and business, and he will have a son from whom he will get much joy. Because Venus comes to the place of Mercury in the natal horoscope, it signifies that he will have power and fame in speaking and reasoning, particularly because they are in conjunction in the fourth (house)'. The popularity of nativities is indicated by their greater presence in surviving manuscripts than horoscopes belonging to any other genres. It is also likely that a large number do not survive since clients probably took nativities of themselves or their children away for future reference. The majority of medieval horoscopes survive in books produced by the astrologers themselves or compiled by later students of the art.

The notebook recording Richard Trewythian's astrological practice contains a number of horary charts, a genre which is hardly present in Greco-Roman astrological texts but achieved popularity with Arabic astrologers who had encountered it in Indian sources. Horary astrology was used to determine the outcome of specific questions in terms of a figure drawn up for the moment when the question was formulated. Trewythian also practised, though to a lesser extent, electional astrology, in which the planetary positions were studied in order to establish the most suitable time for beginning an activity. In 1452, for instance, he drew up a horoscope to determine the best time for his client to depart from town to the war. Clients probably visited the astrologer at his home, where they would reveal the intimate problems of domestic crises and pregnancy, queries relating to business transactions, fears of the outbreak of war and quests for treasure. Before their eyes the hopes and anxieties they had expressed would be reconstructed in the form of a representation of the heavens from which the astrologer drew his reply. In less than a quarter of an hour, perhaps, the whole process would be over. One of the most common topics of Trewythian's horary practice was questions dealing with theft. Two horoscopes he constructed 'for the Abbot' are concerned with the theft of a gold cup which is sketched inside one of the figures (25). Trewythian was able to describe the Martian characteristics of the thief for his client: 'He is of a ruddy complexion with greasy brown hair and often has red pimples on his face. He has a scanty beard and small eyes; his body is coarse and crooked. He is a sower of weeds and discord between men.' Unfortunately, although the thief is said to still possess the object and to have a desire to talk about his crime, the astrologer does not think it will be recovered.

THE PLACE OF ASTROLOGY
IN MEDIEVAL SOCIETY

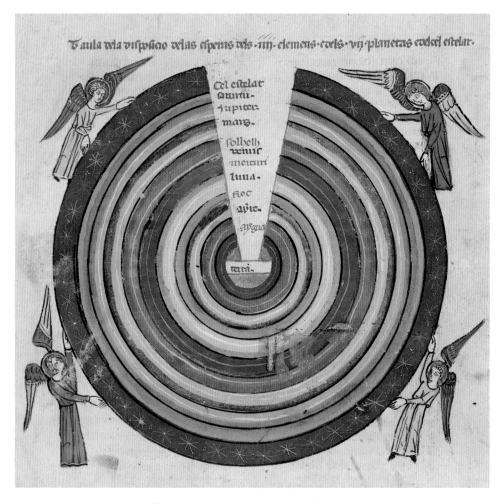

The art of astrology was integrated with a wider set of beliefs and practices in medieval society: cosmology and natural philosophy, medicine, agriculture, weather-forecasting and alchemy. According to medieval cosmology the earth nested within a series of concentric spheres of the elements, planets and fixed stars (26). This world was divided into two distinct domains. Below the orb of the moon to the centre of the earth, the spheres of the four elements and all the bodies composed of them were corruptible and changing. Above lay the incorruptible celestial region of the seven planetary spheres, the eighth heaven or sphere of the fixed stars, the crystalline ninth heaven and the tenth heaven

26. *Cosmological diagram, early fourteenth century. Royal MS 19 C 1, f.50.*

or *primum mobile*. The tenth heaven initiated the movements of all the other orbs – in the simplified diagram represented here this cosmological motion is instigated by angels. Beyond it was an unmoving sphere called the empyrean heaven which enclosed the world within it and was the dwelling of God, the angels and the blessed.

The place of astrology within this cosmology was assured by the pre-eminence of Aristotelian physics in natural philosophy from the twelfth century onwards. Because Aristotle (384–322 BCE) had argued in the *Meteorologica* and elsewhere that the processes of generation and decay on earth were caused by changes in the heavens (27), the celestial bodies were included as causes in the long chain of influence which descended from God and the angels to earth. Vivid examples of celestial influence such as that of the sun upon the seasons or the moon upon the tides gave further support to 'natural astrology'. The influence of the planets on the weather, minerals, plants and animals and the consequent

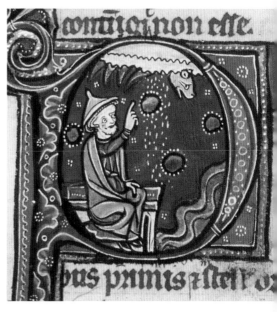

27. Observation of meteorological phenomena, fourteenth century. Harley MS 3487, f.140v.

importance of astrology in medicine, agriculture, meteorology and alchemy was almost universally accepted. Only the influence of the planets upon humans caused serious unease in the Middle Ages. Many compromise solutions to this problem proposed by both astrologers and churchmen placed the bodies, passions and mobs of men under the rule of the stars, while safeguarding their souls and reason, and the free will of the individual.

While theologians debated the precise role of astrology in the cosmological scheme, texts were circulating which pinpointed precise relationships between the celestial bodies and sub-lunary objects. Astrological herbals and lapidaries described particular plants and stones which received their form and nature from the planets, zodiacal signs and sometimes the fixed stars. As well as listing their properties, these genres often provided instructions for enhancing the natural power of plants or stones by timing their use in accordance with the celestial influence of their ruling planet, constellation or star. The theory and practice of natural astrology and other

occult arts achieved wide circulation in the popular and influential *Secretum secretorum* (see 21, 28, 29 and 43), a text purporting to be an epistle from the philosopher Aristotle to Alexander the Great. As well as advocating the practice of learned astrology, many versions of this work contained sections describing celestial influences on plants and stones.

The *Secretum secretorum* distinguishes two approaches to natural astrology: knowing the properties of things and the operation of natural things. According to this text each plant follows the virtue of one of the planets, a claim illustrated in a

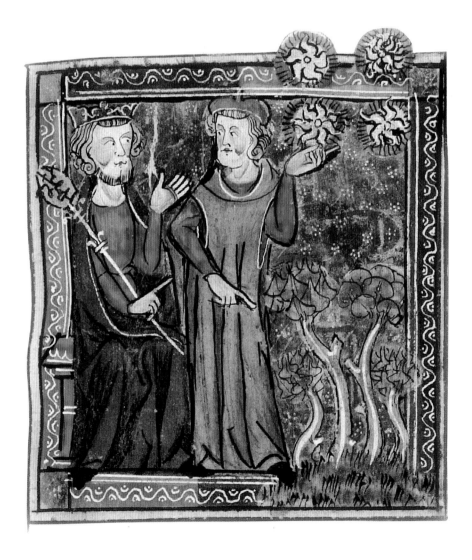

28. *Planetary influences on plants, c.1327. Add MS 47680, f.49.*

miniature from an elaborately illuminated manuscript made for King Edward III of England in 1326–1327 (28). Plants lacking light are said to be governed by Saturn, while those which flower but bear no fruit are governed by Mars. A few practical recipes are provided, including one for using seven seeds from a tree named *androsman*. The user is advised 'to crush them in his name (that of the person to be afflicted), Venus arising, so that her rays may touch them. Give it to him to drink or eat, and dread will abide still in his heart and he will always obey you, during your whole life'. An unnamed species with wide branches and white flowers is 'of the property

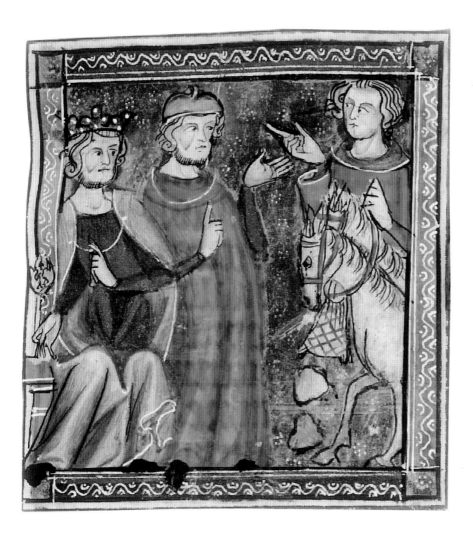

29. *Two stones of marvellous virtue*, c.1327. Add MS 47680, f.48.

of Mars and Mercury and the nature of fire and air. The bearer of it shall never be without sluggishness while it is upon him'. Another miniature in this manuscript depicts a servant of the King bringing him 'two stones of marvellous virtue that are found in dark places'. These rise to the surface of water and descend to the depths according to whether the sun is rising or setting (29). Descriptions of plants and stones in the *Secretum secretorum* were appropriate to the context of Alexander the Great receiving knowledge of the wonders of nature from his counsellor Aristotle. This image of the king as a bearer of occult wisdom was desirable to rulers in the Middle Ages who were expected to possess the miracle-working powers of a divinely appointed monarch.

30. Activities suitable for the twenty-fifth day of the moon, c.1450. Harley MS 1735, f.12v.

Simple aphorisms about the moon's influence on plants and animals, the seasonal occupations of farming and the weather are found in other contexts: works of lunar divination and even writings on husbandry. Illustrations of a hunting dog, a plough and a basket of seeds accompany a divinatory text which states that the twenty-fifth day of the moon is 'good for hunting and beginning tilling and sowing corn' (30). Farmers who consulted such treatises would not have understood or been interested in the complex theories and calculations of learned astrology, although their popular beliefs were based on the same premises of celestial influence. Likewise sailors who were aware of the effects of the sun and moon on the seasons and tides and predicted the weather from physical signs in these celestial bodies may not have consulted astrological textbooks, but they were making a similar association of

celestial and climatic change. The encyclopedist Isidore of Seville (570–636) linked the iconography of zodiac signs with the meteorological conditions appropriate to their calendrical month. His comments were copied into an Italian manuscript which depicts Capricorn, somewhat unusually, as a unicorn (31). This tinted drawing is accompanied by a note that the ancients often represented the sign as a goat with the tail of a fish because of the heavy rain falling in December. A rather more systematic attempt to relate celestial phenomena to the weather is found in a late thirteenth-century manuscript owned by William Herbert, Regent Chancellor of the Friars Minor at Oxford (32). Astrological tables showing the daily positions of the planets for the year 1269/70 are accompanied by marginal notes on the weather. It seems that

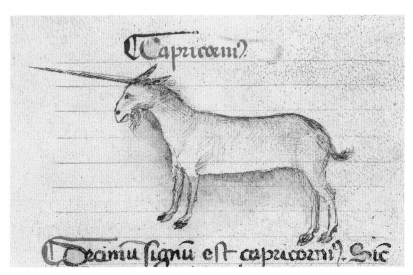

31. Capricorn depicted as a unicorn, c.1454. Add MS 41600, f.3v.

Oxford did not have a white Christmas in December 1269. According to the annotator, there was a dawn frost every morning from the 22nd to the 29th but this melted quickly and days of fine weather were experienced.

Astrological symbols entered medieval awareness as part of the iconography of time, with the planets linked to the hours and days of the week (33) and the zodiac signs to the twelve months. The signs Aries, Taurus, Gemini and Cancer (34) illustrate Bede's *De temporum ratione* (c.722–725), an influential treatise on computus, that is the measurement of time in order to construct the Church calendar. For Bede the zodiac was a convention of astronomical measurement, part of the apparatus necessary to calculate the moveable Church feast of Easter which involved elaborate co-ordination of solar and lunar data. In his work the zodiac signs are accompanied by a poem

32. *Astrological tables with notes on the weather for December 1269. Royal MS 7 F VIII, f.178v.*

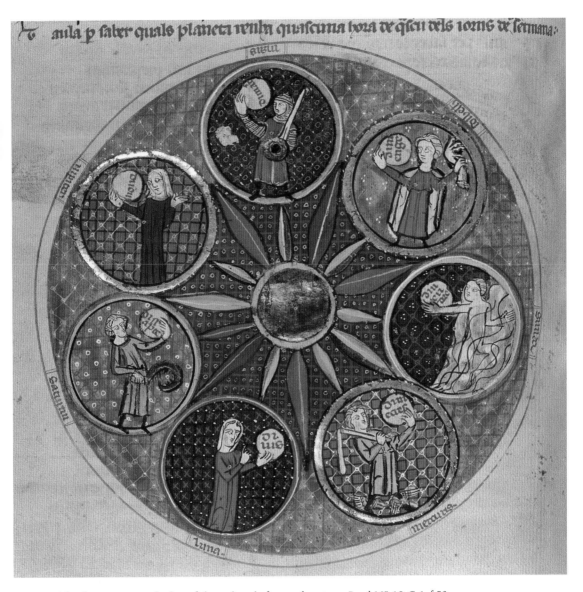

33. *The planets governing the days of the week, early fourteenth century. Royal MS 19 C 1, f.53v.*

which links each to a month in the solar calendar. Curiosity about the mythological and astrological significations of the zodiac and planets is, however, apparent in the margins of many computus treatises. In this thirteenth-century manuscript of Bede the scribe has added notes on the Greco-Roman myths linked to two of the signs: the heavenly twins Castor and Pollux (Gemini) and the Bull-shaped Jupiter who carried off Europa (Taurus).

Computus treatises were frequently accompanied in manuscripts by short divinatory texts dependent, like the calendar, upon calculating the movements of the

43

34. *Aries, Taurus, Gemini and Cancer, Bede's* De temporum ratione, *thirteenth century. Egerton MS 3088, f.17v.*

sun and moon. These were easy to use and popular throughout the Middle Ages. Some kinds were closely linked to the information provided by the calendar, offering general predictions for the year according to the day of the week on which New Year's Eve, the first of January or Christmas Day fell. Others related the position of the sun in the zodiac to the characters of individuals or weather forecasting. According to a work of thunder divination, for instance, 'when it thunders in Gemini (ie when the sun is in this sign) there will be much rain and hail, wheat will multiply and many creeping worms will come forth'. The manuscript with illustrations of Capricorn (31) and the other zodiac signs also contains a computus treatise and an illustrated copy of the *Liber introductorius* by the thirteenth-century astrologer Michael Scot. The latter work gives brief character descriptions and predictions concerning the natives born under every sign and constellation. If a man is born under the constellation of

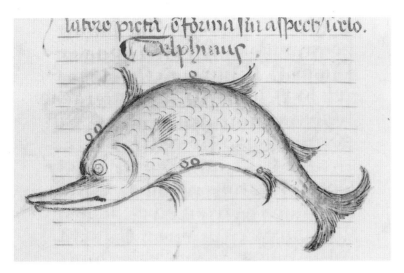

35. *The constellation of the Dolphin, c.1454. Add MS 41600, f.49v.*

the Dolphin (35), for instance, 'he will be easily entertained... he will see and hear great novelties. A traveller, he will cause harm to many through seduction. He will be poor rather than rich, and yet he will live without great labour of his body'.

Calendars illustrated with zodiacal signs were present not only in manuscripts concerned with the measurement of time but also in prayer books. The priest's breviary, a book for his private devotion, contained a calendar with a full list of the Church feasts and their accompanying prayers. From the twelfth century onwards this type of volume was increasingly adapted for secular use as a compendium of devotional texts addressed to the Virgin corresponding to the eight canonical 'hours' of services. These hugely popular 'Books of Hours', usually small and very decorative, were intended for the private use of ordinary people. They opened with a calendar in which the zodiac signs headed lists of saints days and often intermingled with their portraits and religious scenes. In this context the iconography of the signs achieved a wide audience in a medium attesting to its successful Christianisation. The Italian artist of a French Book of Hours, for instance, illustrated the calendar folio for May with linked images relating to the theme of love and lovers. Gemini is represented as a pair of lovers, together with the creation of Eve from Adam's rib and a couple on horseback (36). On the opposite page Venus, the Goddess of love, is depicted bathing, whilst blindfolded Cupid stands on the riverbank.

It is very likely that the integration of zodiac signs with the medieval calendar year increased the credibility of links made in natural astrology between the heavens,

ꝒEMINI

KL Mayus

habet dies xxxi

Luna vero xxx

	A		
xi	B	N	Philippi et Iacobi vac̄
	C	N	
19.	D	N	Inuentio see crucis vac̄.
viii	E	N	
	F	N	
16.	G	N	Io. ans. ante por. la. vac̄
v	A	Id	
	B	N	Apparitio. S. michaelis
xiii	C		Nicolai epi. va
ii.	D	Id	
	E	N	
x	F	Id.	Sol in gem̄
	G	N	
ii.	A	Kl	Bonifacii mris.
vii	B	N	
	C	Kl	
xv	D	N	
iii	E	Kl	

meteorology and the seasonal activities of farming. For the calendar was also generally accompanied by twelve 'labours of the months' drawn from agricultural activities in the countryside such as the fattening of pigs with acorns in November (37). The labours of the months represent an idealised vision of nature in which sturdy, capable peasants serenely fulfil important agricultural tasks. This ordered world where task,

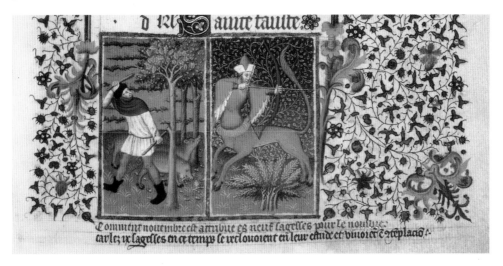

37. *Sagittarius and feeding pigs, c.1423. Add MS 18850, f.11.*

labourer and season are in harmony in a predictable and recurring cycle has something akin to the astrological concordance between planets, types of men and occupations. Yet there tends to be little astrology in medieval calendars, except what is probably accidental. A scene of baking is sometimes illustrated alongside Capricorn (December), whose planetary ruler Saturn governed bakers, and in a late fifteenth-century Spanish breviary, Aquarius, often deemed a signifier of rain, pours his water jug into the river of the landscape below (38). The inventive artists who drew their zodiacal signs down into the world were more interested in witty incorporation than astrological implications: thus Pisces sometimes becomes fish being grilled over fire, Aquarius, a servant pouring wine and Cancer, in the early fourteenth-century Queen Mary's Psalter, is pulled out of the sea by a couple of fishermen (39).

A pictorial convention with certain similarities to the calendrical conjunction of zodiac sign and labour but resting on astrological foundations, is that of the 'children of the planets' (40 and 41). This iconographical tradition demonstrated the extent of celestial influence on human society by placing different social groups and

Opposite page: 36. Gemini; calendar page for June, c.1490–1510. Add MS 11866, ff. 4v–5.

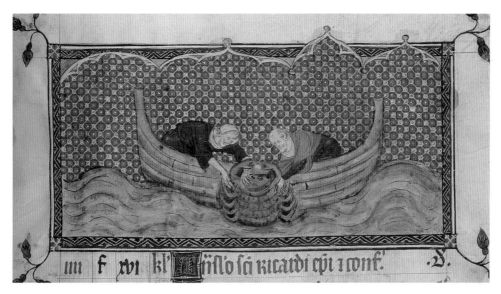

39. Cancer, early fourteenth century. Royal MS 2 B VII, f.77v.

occupations under the rulership of each of the planets. In the first example given here, from Christine de Pisan's *Epitre d'Othea a Hector* (1399–1400), Diana, the goddess of the Moon is seated on the curvature of her planetary sphere aiming a bow and arrow at her 'children' or 'followers' who are arrayed in awkward positions denoting their lunacy (40). Christine de Pisan, as the daughter of a court astrologer and physician to Charles V of France, was well placed to incorporate astrological learning into her literary works. In the *Epitre d'Othea* the planets and their followers are intended to illustrate the range of virtues and vices which a good knight ought to possess or avoid. He must shun the unsteadfastness and folly represented by the Moon but eagerly acquire the eloquence and good preaching denoted by Mercury and his followers (41).

The wide dissemination of astrological ideas and iconography is suggested by the presence of these in two of the most popular books circulating in the medieval period: the *Secreta secretorum* and calendars in Books of Hours. It is more difficult to assess how far this book learning was disseminated to the general populace and in what ways it merged with popular beliefs concerning the influences of the sun and moon. Illustrated Books of Hours could be used by the semi-literate and the common practice of reading works aloud would have increased the transmission of astrological beliefs and practices. But it is likely that the most common form of exposure to astrology was through the practice of astrological medicine.

Opposite page: 38. Aquarius; calendar page for January, late fifteenth century. Add MS 18851, f.1v.

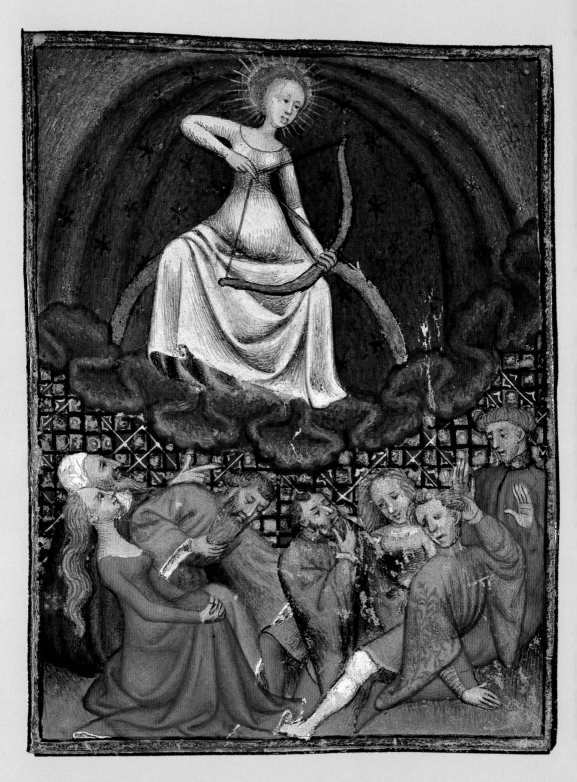

40. The children of the Moon, c.1410–1415. Harley MS 4431, f.101.

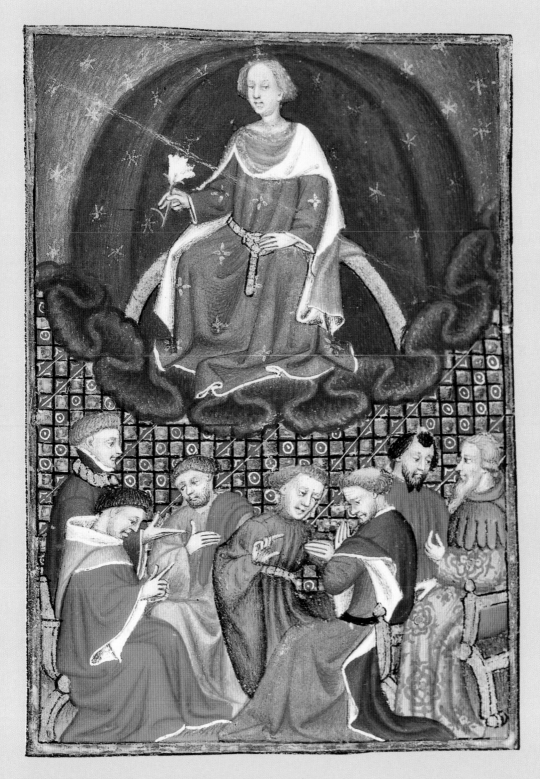

41. The children of Mercury, c.1410–1415. Harley MS 4431, f.102.

ASTROLOGY, MEDICINE
AND MAGIC

Works of astrology translated from Arabic into Latin in the twelfth and thirteenth centuries were eagerly absorbed by medical practitioners attracted by the prestige of linking their art to the study of the heavens. Astrological techniques supplemented rather than replaced traditional Galenic medicine, enabling physicians to discover the most auspicious times for administering medicine, bleeding patients, performing surgery and predicting the course of a disease. By the end of the fourteenth century physicians in many countries were legally required to calculate the position of the moon before they performed operations and a new folding form of the almanac had been developed to enable physicians to carry the tools of astrological medicine to their patients.

In astrological medicine the mathematical and predictive aspects of astrology interacted with late classical theories which situated the microcosm of man's body in relation to the macrocosm. This relationship was often represented in the form of a diagram now called 'Microcosmic Man' (42). The central human figure is bounded by

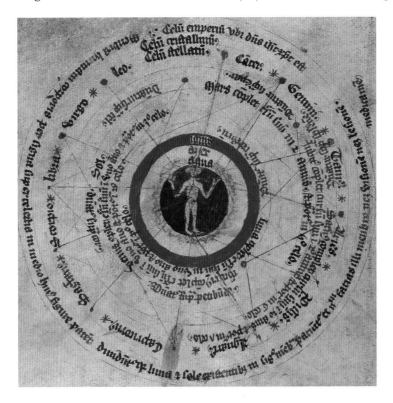

42. Microcosmic Man,
early fifteenth century.
Sloane MS 282, f.18.

52

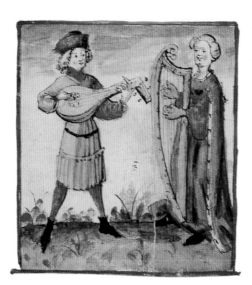

43. The sanguine temperament, 1446. Add MS 17987, f.86v.

the spheres of the four elements and the planets, taking the place of earth in the medieval cosmology (26). Each planetary sphere contains a brief annotation which situates it astronomically, cosmologically and in relation to man. The commentary within the sphere of Saturn, for instance, states that this planet completes its course in thirty years, is in the seventh heaven, and rules over the spleen. Beyond the planetary orbs is the sphere of the zodiac signs, from each of which red lines run to the part of man's body over which they rule and faint black lines link them to their planetary governors. From his head to his feet, from the liver to the heart, man was subject to celestial influences which determined his sympathetic and dependent relationship with the Universe. These lay between man and God, who is not omitted from the diagram: the final enclosing sphere of the universe is 'the empyrean heaven where the Lord Jesus Christ is'.

Astrological medicine was based on a set of principles which originated in authors from late antiquity. Man was composed of the four qualities: heat, cold, moist and dry which combined with the four primary elements: air, earth, fire and water. His character and natural inclinations were determined by the predominance of one of the four constituent and vital fluids or humours in his body: blood (air), yellow bile (fire), phlegm (water) and black bile (earth). These gave him a sanguine (43), choleric, phlegmatic, or melancholic temperament. A healthy body depended on the balance of the humours and illness was often perceived to be the result of a preponderance or deficiency in one of them. Temperaments and bodily disorders were associated with individual zodiac signs and planets, whose influence on a patient could be discerned by

an analysis of his or her horoscope. Men and women under the influence of Saturn, according to Leopold of Austria's thirteenth-century astrological textbook *Compilatio de astrorum scientia*, would be prone to suffer from 'long illnesses and particularly those occuring because of melancholy humours... such as leprosy, gout, fistula, cancer, frosts, quartan fevers, black and white morphew (a skin disease), fetid odours and bad breath from the mouth or nostrils'.

The moon was the most significant planet in astrological medicine; important because of its closeness to earth and the belief that it affected the increase and decrease of the humours in a manner analogous to its influence on the tides. One of the main methods of correcting a disturbance in the balance of the humours was phlebotomy or bleeding, for which certain days of the moon were recommended and others believed to be dangerous. It was considered particularly unsafe to bleed a patient or perform surgery when the moon was in the zodiac sign which ruled the body part undergoing lesion. Hence the physician with an instrument for bleeding on the King's right in a miniature from the *Secreta secretorum* is paired with an astrologer on the other side bearing an instrument for determining the position of the sun and moon (44). The volvelle was another device for locating the position of the moon in the zodiac. An elegant parchment example from the Guild-book of the Barber-Surgeons of York (45) is surrounded by the patron saints of the Guild: Saints John the Baptist and John the Evangelist (at the top), and the patron saints of medicine and surgery: Saints Cosmas and Damian (at the

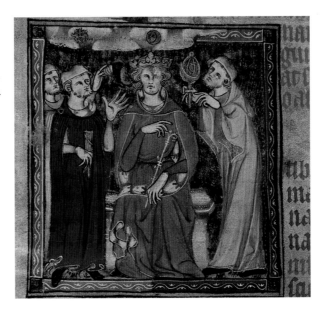

44. *A king consulting an astrologer and a physician, c.1327. Add 47680, f.53v.*

bottom). The user would begin by setting the index of the sun (the moveable disk and pointer) to a particular day in the year on the outer calendrical disk. The central index of the moon (missing here) would then be set to the day of the moon marked in red on the solar index and the user would be able to read off the zodiac sign in which it was placed.

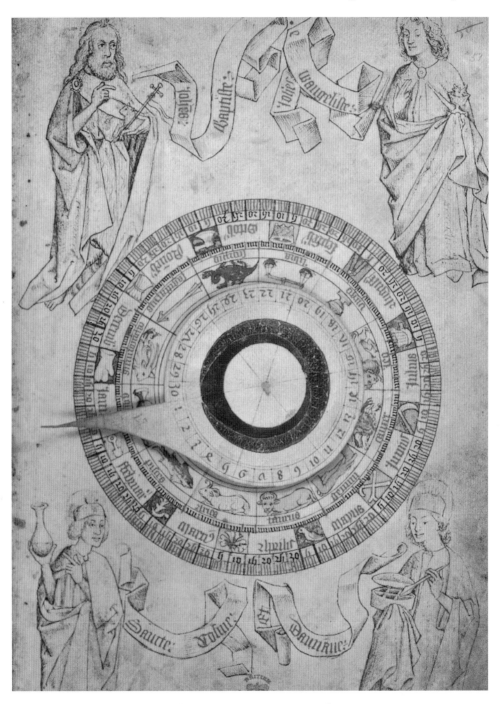

45. The Barber-Surgeons' volvelle, late fifteenth century. Egerton MS 2572, f.51.

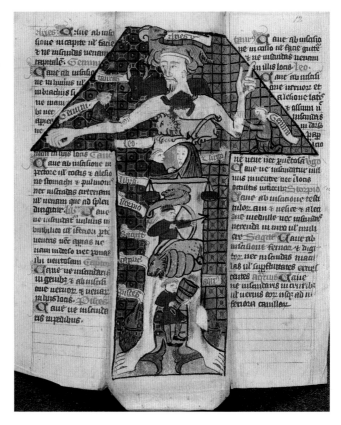

46. Zodiac man from a folding almanac, c.1399. Sloane MS 2250, f.12.

The ubiquitous image of astrological medicine is the zodiac man, a striking depiction of a naked man literally swarming with the zodiac signs which press against the body parts under their rulership (46). As an attractive visual aid which survives in hundreds of copies, it may have been intended to increase the understanding of the patient as well as the physician, impressing him or her with the mingling of the celestial in the medical art. It depicts the bodily rulerships of the zodiac signs and is accompanied by warnings against bleeding or operating at times inappropriate to the moon's position – in this miniature the dangers are underlined by the cautionary gesture of the zodiac man. These figures were often lent a pious air by their almost Christ-like pose and naked passivity, which in at least one case led to their meaning being misconstrued. While undertaking one of his twice-yearly visitations of churches and clergy in 1557, the Archdeacon of Canterbury, Nicholas Harpsfield, was horrified to discover that religious services in the Chapel of Egerton were being performed before an image of a naked man surrounded by the twelve signs. No punishments for the misguided clergy are recorded but he ordered a sculpture of the Crucifixion to be provided immediately.

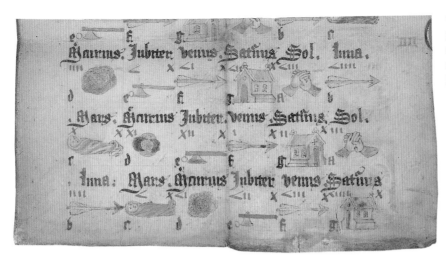

47. Pictorial prognostication from a folding almanac, fifteenth century. Egerton MS 2724.

The pointing zodiac man is from a medical astrological almanac constructed from small folded pieces of parchment sewn together at their ends which were unfolded in sections to reveal part of the calendar, a useful table or an astronomical or medical diagram. Such folding versions of the popular almanac were produced for medical practitioners in the first half of the fifteenth century because they could be conveniently attached to the users' belts when visiting patients. Several surviving folding almanacs also contain pictorial prognostications of various kinds. Related to popular divinatory texts by the days of the moon or the day of the week on which significant feast days fell, their pictorial form suggests that they may have been designed for non-literate users. In the example illustrated here (47), each of the days of the week (a–g) and hours of the day (I–XII) is linked to a planet and a symbol. The Sun is associated with a pair of clasped hands; the Moon, an arrow; Mars, a new-born child, and so on. This form of prognostication was used to identify suitable days and hours for various activities, such as marriage, departing for war or hunting, baptising a child, financial transactions and even the chopping of wood. It was also consulted in order to discern the character or future occupation of a child (merchant, soldier, forester etc) according to the day and hour of birth.

The practice of astrology was never far removed from the occult arts, whether divinatory, magical or alchemical. Popular methods of divination by the days of the moon and the zodiac signs remained closely associated with their more learned counterparts in method and in manuscripts. Geomancy, the art of divination by drawing a series of dots (in the earth or on parchment), borrowed many techniques from astrology although its

practitioners did not require an astrolabe. Often itself considered a branch of astrology, this divinatory art found favour with a number of medieval rulers: the figures illustrated here (48) were copied from a geomancy owned by Richard II. Each represents one of the configurations of dots produced by complex astrological calculations from which the geomancer made his predictions. According to the accompanying table showing the nature and property of each pattern, they are both linked to the planet Venus.

Astrology shared many assumptions with alchemy concerning the nature and classification of the planets and zodiac signs. Of particular importance to alchemy were the links between planets and particular metals: the Sun and Moon with gold and silver, Mercury with quicksilver, later its namesake; slow-moving Saturn with dense and heavy lead, Jupiter with tin, Venus with copper and Mars, the god of war, appropriately with iron. Astrological techniques were also utilised by alchemists, particularly, as in medicine, in order to establish the optimum times for their

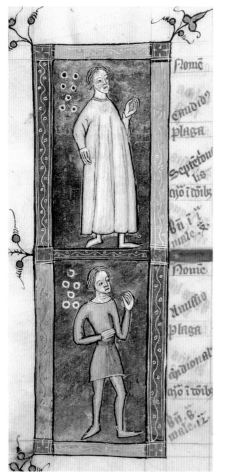

activities. An elaborately illustrated copy of the first five chapters of the *Ordinall of Alchymy* by Thomas Norton of Bristol (c.1433–1513/14), contains vividly coloured horoscopes constructed for different stages in the preparation of the philosopher's stone (*see illustration on page 4*).

Magical uses for astrological images are proposed at the end of a manuscript in which a tinted drawing of the sign Leo illustrates Leopold of Austria's astrological textbook (49). A later scribe has added a recipe to this volume which gives directions for making a talisman of gold or silver with the form of a lion engraved upon it, on the day and in the hour of the sun. According to the author 'this seal should be tied onto a belt worn around the kidneys. I am certain that he who keeps it will never afterwards suffer pain.' Following these instructions is a work attributed to Hermes, *De ymaginibus*, which describes the making of talismans bearing images of the zodiac signs and their individual medical uses. The engraving of astrological talismans for medical purposes was on the

48. *Figures from an astrological geomancy, late fourteenth century. Royal MS 12 C V, f.19v.*

49. *The constellation Leo, c.1350. Add MS 23770, f.13v.*

borderline of acceptable practice. According to the thirteenth-century theologian Thomas Aquinas, engraving magical characters onto an object signified that its maker was attempting to communicate with demons, but engraved pictures possessed a more innocent aspect. They could be used simply to channel the natural power of celestial bodies into a precious stone or metal plate. The acceptability of this practice may have increased following the most infamous use of a medical talisman in the Middle Ages. In 1301 the Catalan astrologer and physician Arnau de Vilanova treated the kidney of Pope Benedict VIII with the lion talisman. The Pope aroused great indignation among the cardinals by claiming that its use had eased his sufferings.

'Omne bonum', a mid fourteenth-century encyclopedia of canon law, theology and general knowledge compiled by an Englishman named Jacobus, delineates the boundaries of 'good' and 'bad' astrology. The illuminated initial (C for *Constellacio*) of an astrologer dressed in scholarly attire (50) presents a warning to students of the art. Although his eyes gaze towards heaven and his right hand rests on an astronomical table, with his left hand he touches or gestures at a magic circle in which a small but monstrous demon is standing. Astrology, according to this text, is permissible when it is useful, that is, 'when it assists the teaching of astronomy or helps farmers and physicians'. Jacobus condemns astrology which serves a magical or superstitious purpose. The miniature suggests that he is referring to magic texts which

50. Astrologer consorting with a demon, c.1350. Royal MS E VI, f.396v.

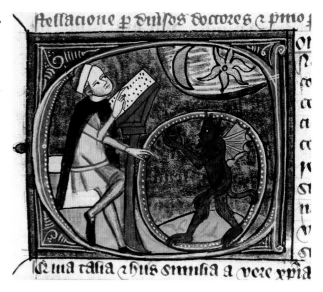

describe the summoning of spirits linked with the celestial bodies and the timing of magic rituals according to astrologically appropriate moments. The planets were a source of ambiguous power in the Middle Ages because philosophers were not agreed on whether their moving spheres could be identified with spirits endowed with a will and soul. Some magic texts claimed to channel the planets' influence according to the astrological rules which defined their strengths and weaknesses in different parts of the heavens and in relation to each other. Others addressed invocations to the spirits of planets and zodiac signs and consequently attracted the charge of idolatry.

For many, perhaps most astrologers, their practice of the art was not incompatible with their faith and could even be used to further their understanding

51. A horoscope for the nativity of Jesus Christ, second quarter of the fourteenth century. Sloane MS 3983, f.49v.

of God and religious matters. It was in this spirit that the theologian Pierre d'Ailly (1350–1420) wrote works defending the practice of Christian astrology and Richard Trewythian opened one of his annual revolutions with the quotation that 'To know and understand belongs to the most glorious, since all knowledge comes from God'. A user of the elegantly illustrated *Liber Albumasaris* (13) constructed a horoscope for the nativity of Jesus Christ on a flyleaf of the manuscript (51), and if the birth of Christ could be analysed astrologically, so too could the possession of piety. According to a work of lunar divination, which claimed that the twelfth day of the moon was the day of Moses's birth, 'whoever is born on this day, he shall be religious' (52).

In the Middle Ages astrologers generally succeeded in maintaining the delicate balance by which their art was respected as a branch of learning and permitted by the Church. The two were inevitably linked, and both came under increasing attack in the early Modern period. Although many proponents of the Reformation and Counter-

Reformation sought to distance themselves from all techniques with a hint of superstition, the substantial undermining of the status of astrology as a learned science came with transformations in cosmological theory. As Aristotelian physics lost its influence and the centre of the Universe shifted away from the earth, the philosophical underpinnings of astrology dissolved and it increasingly failed to live up to the standards of an emerging concept of science. The art of astrology in all its dazzling complexity remained, adrift from mainstream views concerning the nature of the Universe, but of enduring popularity because of its innate appeal to a compulsive human desire to know the future.

52. *Moses and a pious woman born on the twelfth day of the moon, c.1450. Harley MS 1735, f.8.*

BIBLIOGRAPHY

H. Carey, *Courting Disaster. Astrology at the English Court and University in the Later Middle Ages* (London, 1992)

P. Curry, ed., *Astrology, Science and Society: Historical Essays* (Woodbridge, 1987)

J. North, *Horoscopes and History* (London, 1986)

L.A. Smoller, *History, Prophecy and the Stars: The Christian Astrology of Pierre d'Ailly, 1350–1420* (Princeton, 1994)

S. J. Tester, *A History of Western Astrology* (Woodbridge, 1987)

P. Zambelli, *The Speculum Astronomiae and Its Enigma: Astrology, Theology and Science in Albertus Magnus and His Contemporaries* (London, 1992)

For a bibliography of editions and translations of Latin astrological texts and a useful guide to the their terminology see C. Burnett, 'Astrology' in F. A. C. Mantello and A. G. Rigg, eds., *Medieval Latin: An Introduction and Bibliographical Guide* (Washington, 1996), pp. 369–382.

GLOSSARY OF ASTROLOGICAL TERMS

The references to sun and moon indicate astronomical bodies, whereas Sun and Moon refer to their more personified role in disseminating astrological influences.

ANNUAL REVOLUTION: A prediction for the year ahead based on a horoscope drawn up when the sun enters Aries (the beginning of the astrological year).

ASCENDANT: The degree of the zodiac rising over the horizon at the time of birth.

ASPECTS: Angular relationships between planets. The main aspects are conjunction (0°), opposition (180°), quartile/square (90°), sextile (60°), trine (120°).

CAPUT/CAUDA DRACONIS: The points where the moon crosses the ecliptic.

COMBUST: A planet in conjunction with the Sun. Within 17 minutes of the Sun it is 'cazimi' or 'in the heart' and within 17 degrees it is 'under the rays'.

DETRIMENT: A zodiac sign in which a planet's influence is particularly weakened.

DIGNITY: A position which strengthens a planet's influence, for instance when it is placed in its own house, triplicity, exaltation, face or term.

ELECTION: A horoscope constructed in order to determine a suitable time for beginning particular activities, such as marriage, journeys, law-suits etc.

EPHEMERIS: A table listing the positions of the planets and nodal points.

EXALTATION: A zodiac sign in which a planet's influence is strengthened.

FACE: Divisions of 10 degrees within a zodiac sign assigned their own planetary rulers.

FALL: A zodiac sign in which a planet's influence is weakened.

HOUSE: The zodiac signs are the 'houses' of their planetary rulers. Also the name given to the twelvefold division of the local sky.

HORARY: A horoscope constructed for a specific question.

HOROSCOPE: A diagram of the heavens at a given point in time and divided into twelve houses in relation to a fixed point on earth, which specifies the locations of the seven planets within the zodiac.

JUDGEMENT: The conclusion drawn from a horoscope.

JUDICIAL ASTROLOGY: A branch of astrology providing specific predictions for an individual's life and actions.

LOT OF FORTUNE: An important nodal point in the horoscope which is calculated by adding the number of degrees between the Sun and the Moon (or vice-versa at night) to the ascendant.

MIDHEAVEN: The cusp of the tenth house. The influence of a planet positioned here is strengthened.

MUNDANE ASTROLOGY: A branch of astrology concerned with celestial influences on natural phenomena and general predictions.

NATIVITY: A horoscope constructed for a particular birth.

QUADRUPLICITY: A group of four signs possessing one of the quantities: cardinal, fixed or mutable.

SOLAR RETURN: A horoscope constructed on the birthday of an individual and analysed in relation to his or her nativity.

TERM: Divisions of varying length within a zodiac sign ruled over by one of the five planets.

TRIPLICITY: A group of three signs associated with one of the four elements: fire, earth, air, water.

THE AUTHOR

Sophie Page is a Research Fellow at Fitzwilliam College, Cambridge, where she is currently investigating occult interests in medieval monasteries. Her forthcoming articles include 'The Uses of Astrology in Late Medieval England' and 'Image-Magic Texts and a Platonic Cosmology at St Augustine's, Canterbury'.

Front Cover Illustration: *The children of the Moon, c.1410–1415. Harley MS 4431, f.101.*

Half-title Page: *Taurus from Bede's* De temporum ratione, *thirteenth century. Egerton MS 3088, f.17v.*

Frontispiece: *The signs of the zodiac, fourteenth century. Harley MS 4940, f.32.*

Title Page: *The astronomer Ptolemy mistakenly depicted as a king, fifteenth century. Harley MS 334, f.95v.*

Back Cover: *Astronomers on Mount Athos inspecting the heavens, fifteenth century. Add MS 24,189, f.15.*

First published 2002 by
The British Library
96 Euston Road
London NW1 2DB

British Library Cataloguing-in-Publication Data
A catalogue record for this book is available from The British Library

ISBN 0 7123 4744 5

Designed and typeset by Crayon Design, Stoke Row, Henley-on-Thames
Colour origination by Crayon Design and South Sea International Press
Printed in Hong Kong by South Sea International Press